Foreword

It is no secret that self-expression in any form has therapeutic benefits and boosts wellbeing.

This cheery book immediately instils a sense of positivity purely by glancing through it.

Stimulating minds and nurturing emotional health is crucial to self-care, the Lioness Exercise Book ticks both these boxes and more! Creative activities are known to be helpful in reducing symptoms of anxiety and encourages living in the moment. Focusing on the positive is instrumental in supporting the journey of building self-worth and embracing our magnificence.

This is a must have self-help tool for Lionesses & Lion Cubs everywhere.

Corinne Yeadon
Being Better Private Therapy Practice
www.beingbetter.org.uk

This book is dedicated to Karen,

...and to all who, through their bravery,
show that they are indeed Lionesses.

Disclaimer

This book is intended to provide some creative activities which aim to increase self-esteem, confidence, as well as enjoyment. This would have been accessible through the Lioness Courses (groupwork), if not for the worldwide Coronavirus Pandemic.

The book is not intended to replace any counselling, therapy or intervention and it is advised that individuals seek out appropriate and important support from their GP/Primary Care Service as needed.

IN THE EVENT OF FEELING UNSAFE, ALWAYS CONTACT THE EMERGENCY SERVICES

Introduction

This book is aimed at those who have no experience with art, or being creative, except maybe at school.

It's not about art anyway. It's about playing with being creative, just to try and maybe later grow to use it to express yourself in a journal perhaps. There is no right or wrong way; just your own way. No-one is going to judge you or put you down.

This is for YOU, because you deserve this time for yourself.

We often give our time and energy to others but we need something for ourselves.

Jill Boyd & Debs Hooker

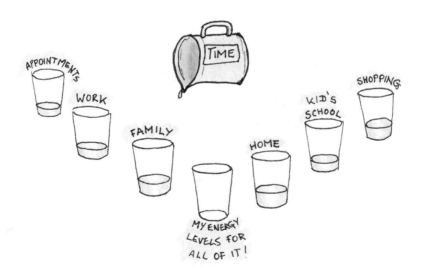

TRY TO NOT FEAR WHAT YOU CAN ACHIEVE...

YOU CAN DO THIS !

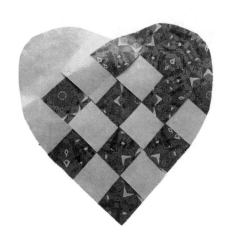

YOU ARE

a **L**ovely person

an **I**ndividual

One-of-kind

Nice

good **E**nough

Strong

a **S**urvivor

6

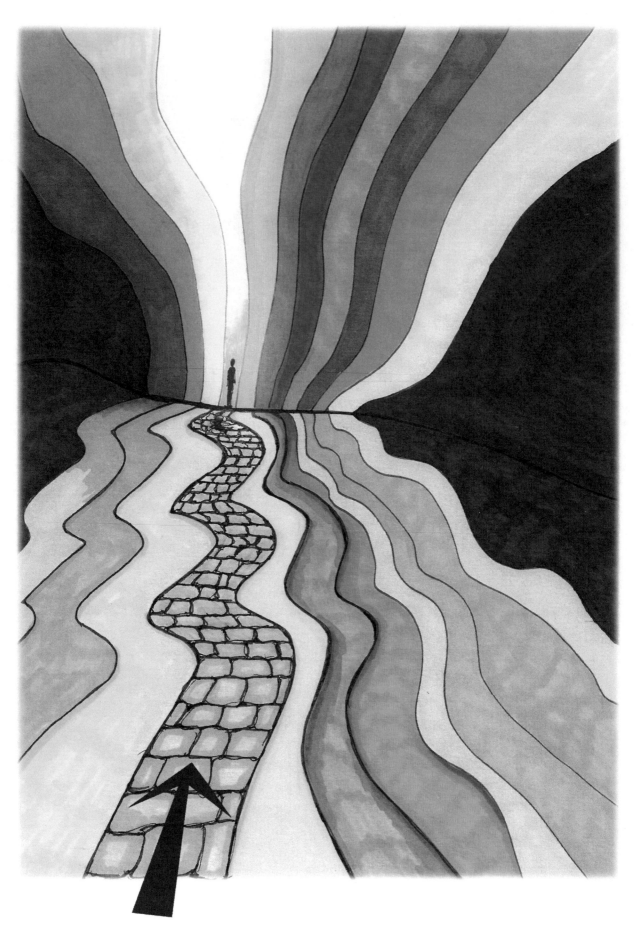

Your journey to rebuilding your
self-esteem and confidence.

TIME

① Draw round a lid or a small plate

② Put a dot in the middle

③ Divide the circle up into slices and label
 each slice with an activity that takes
 up time.

See example below

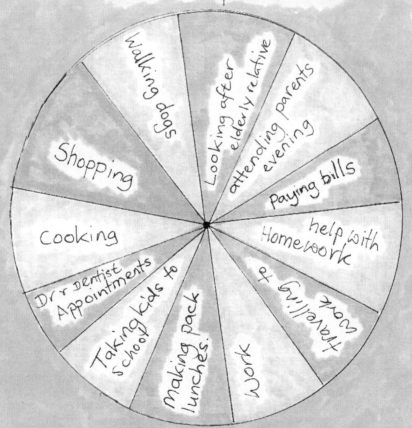

④ How much time is for you?

Food

Novelty

Water

your basic human

NEEDS

Shelter

Others

Sleep

YOU DESERVE YOUR NEEDS TO BE VALUED AND MET

Where you were

NOW

LOOK AT WHO REALLY CARES + SUPPORTS YOU.

DRAW A SHAPE IN THE MIDDLE OF THE PAGE

and write who supports you and cares about you around your shape.
I chose a heart shape.

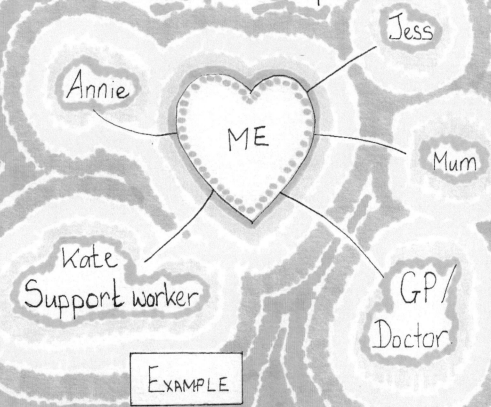

Jess

Annie

ME

Mum

Kate
Support worker

GP/
Doctor.

EXAMPLE

MOVING FORWARD - IN YOUR HEART

My strengths are...

I get help and support from...

I want...

How I will get what I want...

Fold a big piece of paper

Draw the above shape

Cut it out

Complete the guide to help you think about how you can perhaps move forward...

Draw lines up and across and make notes in each section.

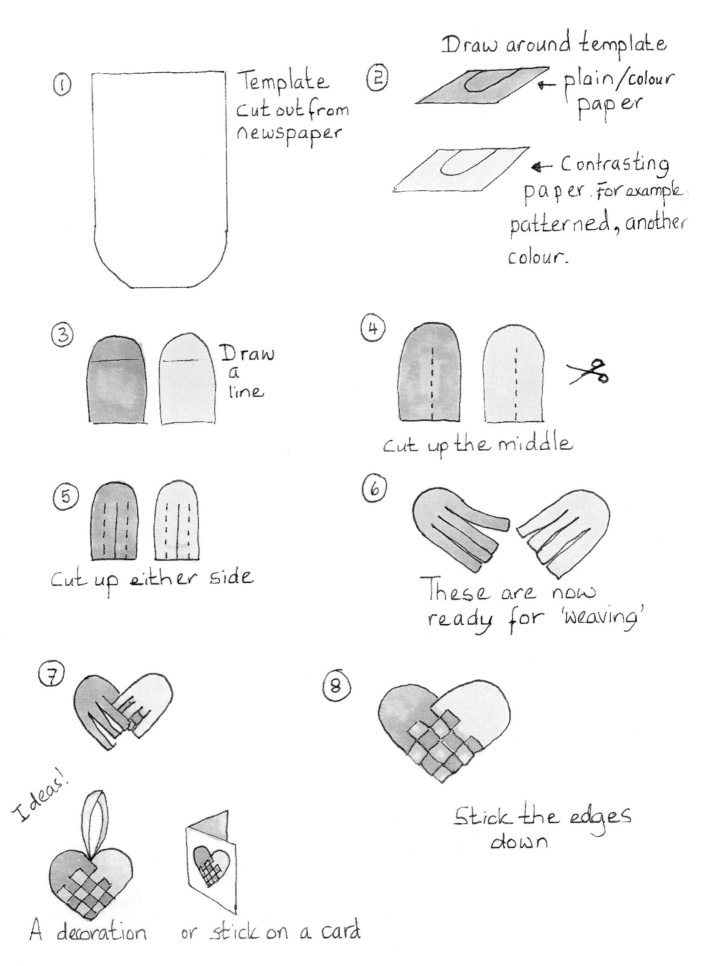

① Template
Cut out from
newspaper

② Draw around template
← plain/colour paper

← Contrasting paper. For example patterned, another colour.

③ Draw a line

④ Cut up the middle ✂

⑤ Cut up either side

⑥ These are now ready for 'weaving'

⑦ Ideas!

⑧ Stick the edges down

A decoration or stick on a card

HOW WOULD YOU DESCRIBE YOURSELF IN A POSITIVE WAY?

Pick a positive word like 'caring'/ 'kind' for example. Put the word in the middle of a piece of paper. Decorate it to celebrate the word and who you are, because you're amazing!

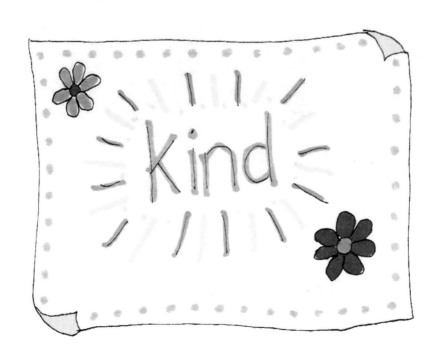

IF YOU WERE ABLE
TO BELIEVE IN
SANTA CLAUS
FOR, LIKE 8 YEARS,
YOU CAN BELIEVE IN
YOURSELF FOR,
LIKE 5 MINUTES

↘ you can do this.

COUNTDOWN TO CALMNESS
WHEN YOU FEEL ANXIOUS...

5 Say 5 things you can see around you

4 Say 4 things you can touch around you

3 Say 3 things you can hear

2 Say 2 things you can smell

1 Say 1 thing you could taste

DRAW SOME BOXES

Have a go at copying these!

Here are some examples of doodle patterns

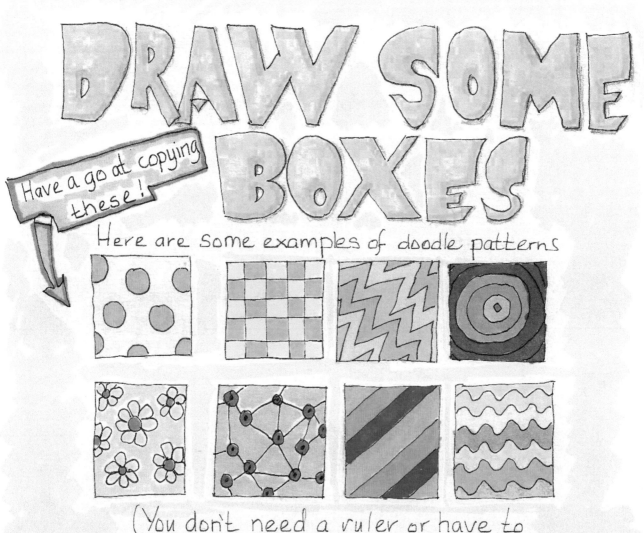

(You don't need a ruler or have to measure anything...)

HAVE A GO AT DOING YOUR OWN PATTERNS TOO

This is just for fun. Try to avoid perfection!

SHADOW ART

Pick an object and put it near a light source like a torch to create a shadow.

Draw around the shadow.

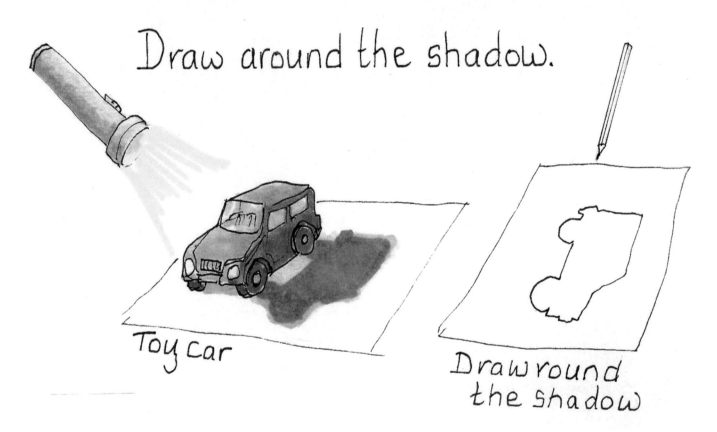

Toy car

Draw round the shadow

TIP:
If you haven't got a torch, just close your curtains and use a lamp or the room lighting.

CAN'T SLEEP? TRY THIS!

Even if you can sleep, have a go at the activity maybe.

① Draw a large number 8

② Rotate your page and do another 8 overlapping the first one.

③ Outline is in black, and rub out the pencil line.

TIP:
Experiment with drawing round objects, like coins. Overlap the drawings though.

④ In each section do a different colour or pattern.

EVERY DAY TRY TO SAY... "I AM GOOD ENOUGH"

Because you are...

Fill a whole page with the affirmation:
'I am good enough'.

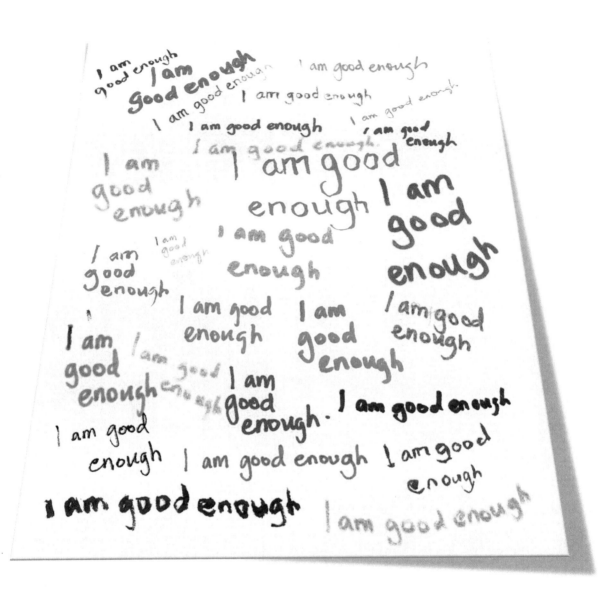

Make it bright. Make it bold!

RECYCLED FLOWERS

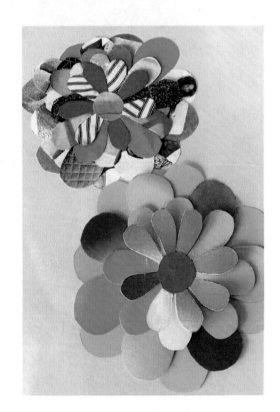

Cut out different sized teardrop shapes (they don't have to be perfect!)

Draw round a coin and cut it out. (use any paper)

Create a beautiful garden of recycled blooms using any scrap paper, food packaging, magazines or junk mail. Stick the petals around the circle.

If you haven't got any glue, maybe draw round the teardrop shapes around the circle and colour them in!

SEASONS IN WINDOWS

Draw 4 squares. Each square is a season. Copy or draw your own in each box.

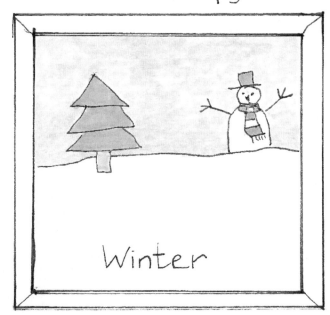

Winter

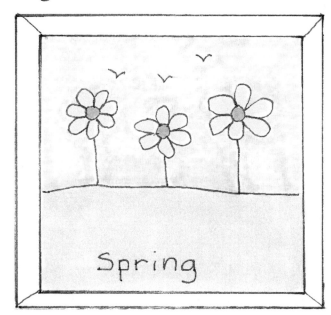

Spring

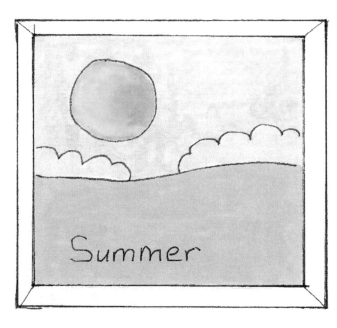

Summer

Autumn

A DRAWING GAME

On a plain piece of paper, after you roll the dice,
copy the drawing in the square for each part
of a funny animal!

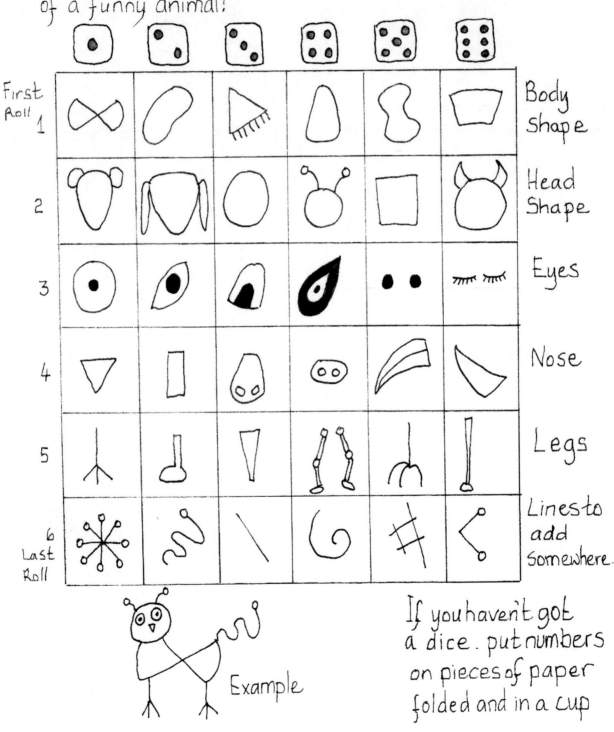

First Roll 1						Body Shape
2						Head Shape
3						Eyes
4						Nose
5						Legs
6 Last Roll						Lines to add Somewhere.

Example

If you haven't got
a dice. put numbers
on pieces of paper
folded and in a cup

'MY SAFE SPACE'

What small items remind you of a happier time? What words calm and reassure you?

What things make you feel safe?

Create a bag to keep all these things for when you need to feel safe.

[ALWAYS CALL 999 IF YOU ARE IN DANGER!]

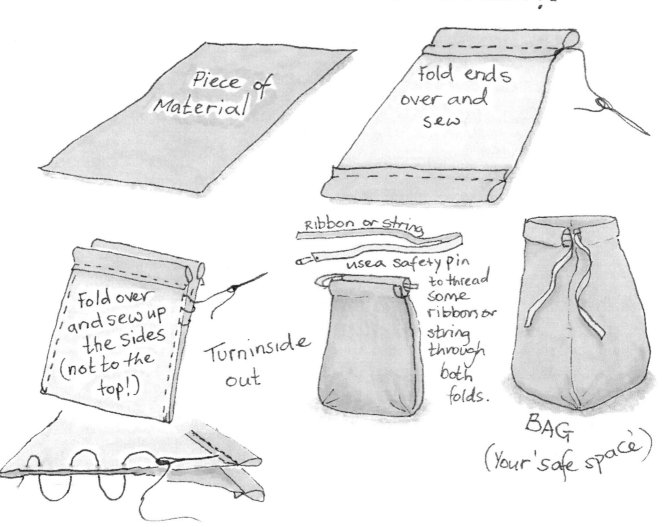

Piece of Material

Fold ends over and sew

Fold over and sew up the sides (not to the top!)

Turn inside out

ribbon or string

use a safety pin to thread some ribbon or string through both folds.

BAG (Your 'safe space')

INSPIRATIONAL QUOTE BOX

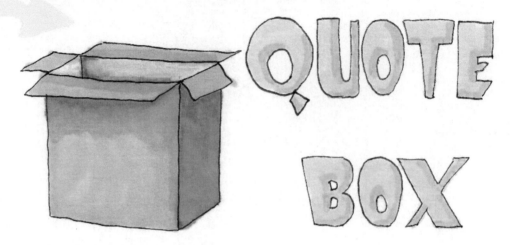

① Find quotes that inspire you

② Write them down on strips or pieces of paper

③ Use a small cardboard box (like a packet from the food cupboard.)

④ Decorate the box, eg paint, cover with wrapping paper.

⑤ Keep the box in a place easily seen like near your bed.

When you feel a bit wobbly, pick out a piece of paper (a quote) at random to hopefully make you feel a bit calmer, more positive or to distract you if you're anxious.

NEW WAYS OF LOOKING AT THINGS.

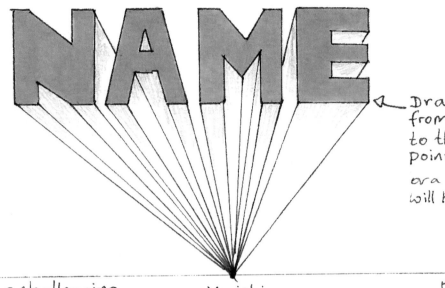

Draw a line from the corner to the vanishing point. (using a ruler or a straight edge will help.)

This is challenging, so don't worry if you struggle with it. Just have fun drawing words/letters like below and maybe do patterns inside them? Have fun!

A way to draw block letters. Start by drawing a line letter.

Line letter in pencil.

Draw around the 'H' with a pencil.

Rub out the line letter.

If you want to make it a square type letter, use a straight edge. Rub out the soft letter.

Vanishing point

Eye line (horizon)

Remember...

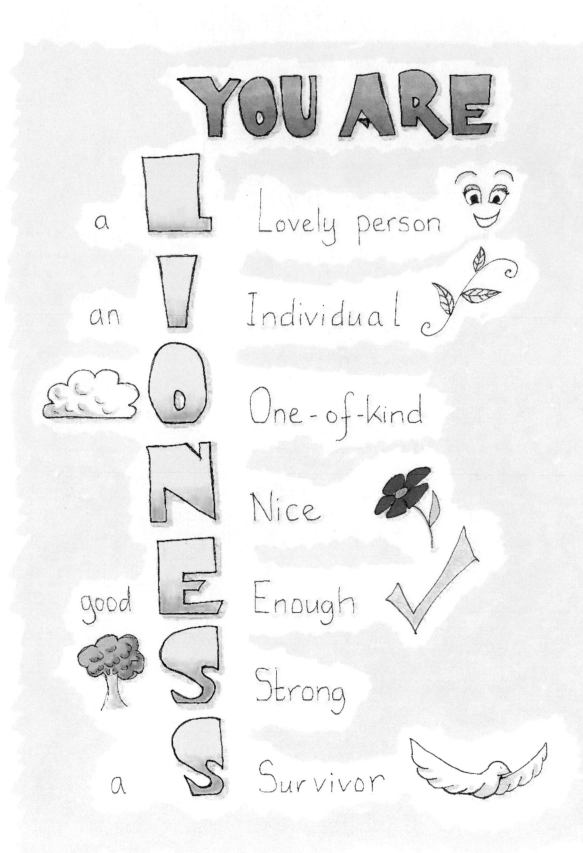

YOU ARE

a **L** Lovely person

an **I** Individual

O One-of-kind

N Nice

good **E** Enough

S Strong

a **S** Survivor